THE ONE & THE MANY

READINGS FROM THE WORK OF

RABINDRANATH TAGORE

TRANSLATIONS BY WILLIAM RADICE
AND KETAKI KUSHARI DYSON
PHOTOGRAPHS BY JOHN M. BERRIDGE

To my sons Stefan and Peter

Published by
Bayeux Arts, Inc.
119 Stratton Crescent, S.W.
Calgary, Canada T3H 1T7

Designed by Carbon Media Inc.,
Christine Spindler and George Allen

Canadian Cataloguing in Publication Data

Tagore, Rabindranath, 1861–1941
The One and the Many

ISBN 1-896209-34-3

I. Berridge, John M. 1938 - II. Radice, William, 1951-
III. Dyson, Ketaki Kushari, 1940- IV. Title.
PK1722.A2R32 1996 891'.4414 C96-910760-9

The Publisher gratefully acknowledges the generous support of
The Alberta Foundation for the Arts

When the voice of the Silent touches my
words
I know him and therefore I know myself.
Fireflies

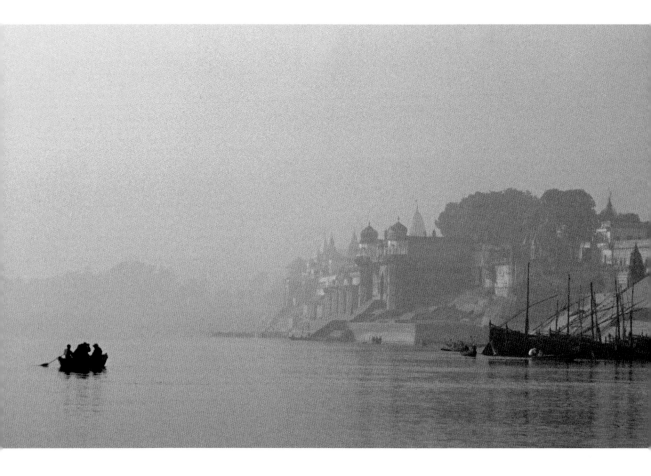

PREFACE

For the past number of years I have had the opportunity to share my deep admiration for Rabindranath Tagore (1861–1941) with students taking my seminar on religion in modern India. This collection of readings and photographs will serve to introduce Tagore to a much wider audience.

As I contemplated combining a modest selection of readings with my own photographs of India, it soon became clear that a primary concern must be that the reader should be presented with the best possible translations of Tagore's Bengali originals. Both William Radice and Ketaki Kushari Dyson have recently published new translations of some of Tagore's poetry. I am very grateful to both of these distinguished scholars for graciously accepting the invitation to work with me on this book. William Radice has been involved in the project from its very early stages. Not only did Dr. Radice kindly agree to write an Introduction, but he has also completed translations for this book of a number of the aphorisms contained in *Sphuliṅga*, a Bengali work which has never before been translated into English. The translations of Tagore's poetry made by William Radice and Ketaki Kushari Dyson have been published by Penguin Books and Bloodaxe Books, respectively. I would like to express my gratitude to both publishing houses for granting permission to

include these translations. I also wish to thank William Radice for granting permission to reproduce excerpts from three of Tagore's letters. These translations have been taken from another of his recent publications — *Rabindranath Tagore. Selected Short Stories*, also published by Penguin Books. In addition to the aphorisms from *Sphuliṅga*, I have included some of the aphorisms which are contained in the collections of sayings entitled *Fireflies* and *Stray Birds*, both published by Macmillan Publishing Company.

I discovered India long before I discovered Tagore. My first visit to India took place almost forty years ago, when a friend and I motored from Paris to the southern tip of India. Like so many others who have fallen in love with India, I have returned many times, always with camera in hand. For the most part, recent visits have taken me to rural areas of India and Bangladesh. It is fitting that many of the photographs in this book portray the people and landscape of Tagore's beloved Bengal, now divided between West Bengal in India and Bangladesh. It is my sincere hope that the photographs may also reflect something of Tagore's vision of the harmonious relationship between the One and the Many. Their quiet images depict the common-place, which for Tagore was always a

source of wonder. In the matter of placing photographs with particular readings, generally I have followed an intuitive rather than a literal approach. The poems and letters have been arranged chronologically, but the selection is my own. Likewise, the three section headings — *The Golden Boat, Wild Birds,* and *The Evening Lamp,* which are English renditions of the titles given to three of Tagore's Bengali collections of poems — reflect what seemed to me intuitively to be right.

Taking photographs in rural India has made it possible for me to catch glimpses of the lives of a number of remarkable individuals. I am deeply grateful to the many men and women who have warmly welcomed me into their homes and courtyards and who have participated in this project with such enthusiasm. Children of every age have been delightful companions. Greeting me at my hotel in the morning, and often accompanying me throughout the entire day, they have also proved to be very trustworthy assistants, keeping a watchful eye on my camera equipment, and often engaging in a little crowd control as well!

I have also enjoyed spending time by myself. I devote some days to walking and taking photographs of Nature. Although I have often admired and photographed some of India's impressive architectural monuments, I have not included any such photographs in this book. Since the primary purpose of the photographs is to complement the readings, it seemed to be more appropriate to select images of a very different nature. Moreover, I have noted how my own interests and concerns have changed over the years. For example, I have visited Khajuraho, the site of several magnificent medieval Hindu temples, on a number of occasions. During my most recent visit I paid but scant attention to the temples, and instead spent a wonderful day taking photographs of the sparrows in the thickets surrounding the temples. One of these photographs has been placed with a reading from *The Borderland.*

I would like to take this opportunity to thank the many good friends who have looked at my photographs and whose honest comments have been very helpful to me in making my final selection. I have benefited greatly from the sound advice given by Sarah Stouffer. Two visits to Santiniketan in West Bengal have afforded me the privilege of meeting a number of scholars conducting research on various aspects of Tagore's work. Sushobhan Adhikary helped to make my most recent visit to Santiniketan during the summer of 1995 a most memorable one. In Bangladesh I had the good fortune to enjoy the kind hospitality of Ashim Kumar Das of Rajshahi University. I have learned a great deal from Mr. N. L. Tak of Jodhpur, who, on three separate occasions, has driven me to remote parts of the state of Rajasthan. I am grateful to Miss Supriya Roy and the Library of the Rabindra Bhavana of Visva Bharati University in Santiniketan for permitting me to include the photograph of Tagore taken by Sambhu Shaha. I wish to thank the University Council for Research of St. Francis Xavier University for its financial support of my most recent trip to India. Although I thought of com-

bining my colour photographs with readings from Tagore before I came across the (black and white) photographs that accompany Martin Kämpchen's German translations of Tagore's aphorisms and other poems (see William Radice's Introduction, p.14), I am very grateful for the help that his translations gave me in choosing aphorisms from *Sphuliṅga*.

Finally, I wish to express my gratitude to those who have worked so closely with me on this book.

Collaborating with my two British colleagues has been a most enjoyable and rewarding experience. I also wish to thank Dr. Ashis Gupta of Bayeux Arts Inc. for his keen interest in this project and for kindly agreeing to publish our work. Special thanks must go to Christine Spindler and George Allen of Carbon Media, who are responsible for the design of the book.

John M. Berridge Antigonish, Canada, June 1997

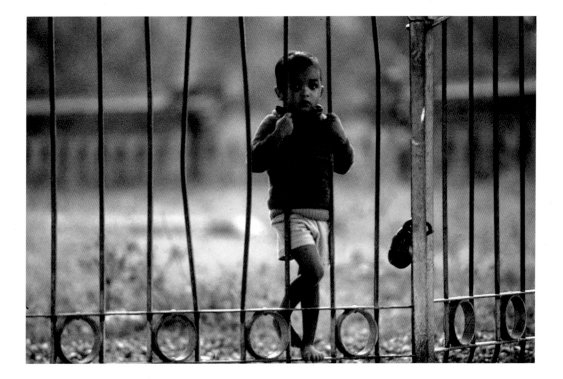

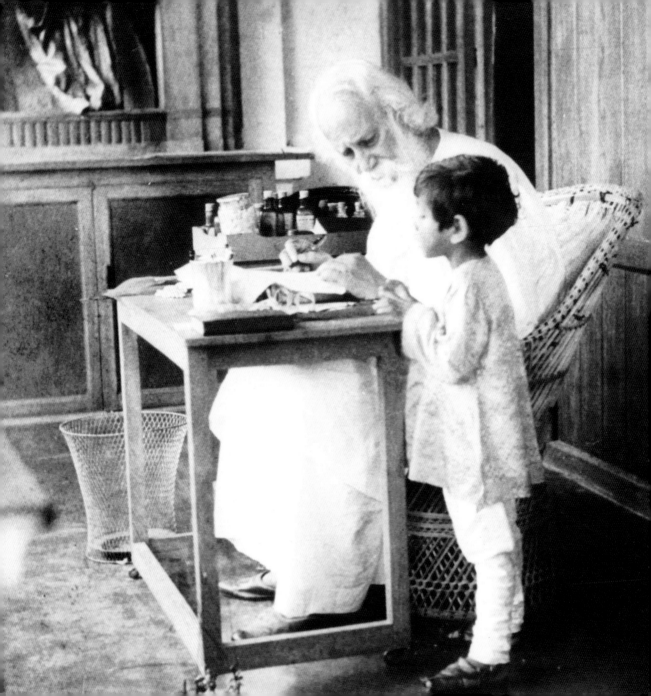

INTRODUCTION

If one reads the beautiful Bengali sermons that Rabindranath Tagore delivered between 1908 and 1914 to students and staff at his school at Santiniketan, certain reoccurring words acquire a haunting resonance. The same religious and philosophical ideas as in the sermons can be found in books of his (equally eloquent) English lectures, such as *Sādhanā* (1913) or *The Religion of Man* (1931). But words — especially abstract words — can be richer in one language than their equivalents in another. Tagore commented on this problem in his English lecture 'What is Art?', published in *Personality* (1917):

> For instance, the English word 'consciousness' has not yet outgrown the cocoon stage of its scholastic inertia, therefore it is seldom used in poetry; whereas its Indian synonym 'chetana' is a vital word and is of constant poetical use. On the other hand the English word 'feeling' is fluid with life, but its Bengali synonym 'anubhuti' is refused in poetry, because it merely has a meaning and no flavour.

Tagore's Bengali sermons are not poems, but like much of his best prose they are deeply poetic in spirit, and it is a poetic resonance that their key-words acquire. One such word is *pūrṇatā*, which means 'fullness' or 'completeness'. The word is used in at least one of the poems included in the present book —'Tumultuous days...' from *Sphuliṅga* (p.101), where 'restlessness' (*cañcal*) is described as always moving towards a state of calm, motionless *pūrṇatā*.

Fullness, completeness, wholeness: Tagore's numerous and varied endeavours were a life-long quest for the ideal that those words express. The ideal compelled him to be a man of action as well as a poet, a practical educationist as well as a thinker, a painter and musician as well as a writer. It made him strive for an intellectual reconciliation of art, religion and science; for a harmonization of Indian and Western traditions; for a balance of the creative, moral and rational.

The quest and the achievement were unique. Which other poet, in any age or country, has in addition to twenty-nine collected volumes of writings composed two thousand songs, painted three thousand paintings, founded and managed a school and university, acted in his plays, travelled the world,

and had songs adopted as the national anthems of two countries (India and Bangladesh)? But all-embracing synthesis was also the goal of the leading figures of the 19th century Bengal Renaissance from which Tagore stemmed. His frequent generalizations about the differences between East and West may seem too sweeping today; but 19th century Bengalis, brought into contact with the culture of their imperial rulers, exposed to Western literature, history and philosophy through English education, were deeply concerned with the clash and harmonization of East and West. The challenge was first taken up by Rammohun Roy (1772–1833), who by translating the Sanskrit *Upaniṣads* into Bengali searched for religious resources that would be acceptable to modern Indians. It was continued by the educationist and social reformer Ishvarchandra Vidyasagar (1820–91) in the Sanskrit-based yet modern curriculum he devised at Sanskrit College; by the poet Michael Madhusudan Datta (1824–73), who blended the Indian epic tradition with Homer and Virgil; by Bankimchandra Chatterjee, who applied a modern historical awareness to fiction and mythology; and by Tagore's father Debendranath (1817–1905), whose monotheistic religious reform movement, the Brahmo Samaj, provided the basis of Rabindranath's own outlook.

The basis, but not the fulfilment. For Tagore, *pūrṇatā* required more than the Victorian high-mindedness of Brahmoism. It needed to incorporate other traditions and influences, both Indian and Western. As an Indian poet, he built on the intricate heritage of Sanskrit court poetry, especially Kalidasa. As a Bengali, he was steeped in the medieval Vaishnava tradition of songs about the love of Radha and Krishna. As one who turned his back on Calcutta and preferred the rivers, land and people of rural Bengal, he drew inspiration from folk poetry, Bengali *yātrā* (itinerant popular theatre) and the mystical songs of the Bauls. As a product, nonetheless, of one of the most cultivated and outward-looking families of Bengal, he learnt from Western literature: from Shakespeare, Wordsworth, Keats and Shelley; while French fiction, admired and translated by his brother Jyotirindranath, showed him new ways forward for the short story and novella. As a world citizen who — especially after he won the Nobel Prize in 1913 — met or corresponded with some of the leading figures of his time, he added to the synthesis ideas from physics, evolution, modern agronomy and pedagogy, internationalism, birth control, rural reconstruction. Above all, as a writer, he attempted almost all the genres: lyric, dramatic and narrative poetry; stories both realistic and supernatural; novels psychological and political; essays on literature, politics, linguistics, crafts, travels…

Pūrṇatā, however, is not achieved by sheer diversity of work. For it to be real, it must derive from a perception of unity, *aikya* (another keyword): a single spirit underlying and harmonizing all things. In being so preoccupied, throughout his life,

with the realization of that spirit, Tagore was in line with India's age-old religious and cultural traditions. He wrote in *The Religion of Man:*

> The poet saint Kabir has also the same message when he sings:
>> *By saying that Supreme Reality only dwells in the inner realm of spirit, we shame the outer world of matter; and also when we say that he is only in the outside, we do not speak the truth.*

According to these singers, truth is in unity and therefore freedom is in its realization. The texts of our daily worship and meditation are for training our mind to overcome the barrier of separateness from the rest of existence and to realize *advaitam*, the Supreme Unity which is *anantam*, infinitude. It is philosophical wisdom, having its universal radiation in the popular mind of India, that inspires our prayer, our daily spiritual practices. It has its constant urging for us to go beyond the world of appearances, in which facts as facts are alien to us, like the mere sounds of foreign music; it speaks to us of an emancipation in the inner truth of all things, where the endless *Many* reveal the *One*.

When Tagore won international fame, and gave speeches all over the world as a long-robed long-bearded representative of the Mystic East, there was a tendency to put him into the same category as India's 'poet-saints', her yogis or ascetics; to see him as a direct successor to Swami Vivekananda (1863–1902), the Hindu monk who launched at the World's Parliament of Religions in Chicago in 1893 a deliberate 'Mission to the West'. W. B. Yeats, in his introduction to *Gitanjali*, the book that won Tagore the Nobel Prize, projected Tagore in that way. But this was a misconception, not just because Tagore was a writer (a Bengali writer), not a monk or guru, but also because his sense of the spiritual had several distinctive features.

It derived, first of all, from a profound responsiveness to Nature. One can call this pantheism, if one likes, and relate it to the English romantic poets (Shelley's 'Ode to the West Wind' was a special favourite of Tagore's); but it had a cosmic reach that was Indian — the same reach that we find in the *Upaniṣads*, or in the sacredness traditionally ascribed in India to the Himalayas or the mighty Ganges. Tagore loved his native Bengal, its rivers, plains, trees and flowers — and his writing is full of his intimate knowledge of it; but the heart of his pantheism was the sun, the awesome tropical sun of India that Hindus greet at dawn with the *Gāyatrī* mantra — the sun that the poet of the *Īśā Upaniṣad* hailed with words that Tagore incorporated into Poem No. 9 of *The Borderland* (p.107 in the present book). The sun and its light gave Tagore in his teens his first conscious experience of the spirit, recalled in *My Reminiscences* (1917):

The end of Sudder Street, and the trees on the Free School grounds opposite, were visible from our Sudder Street house. One morning I happened to be standing on the verandah looking that way. The sun was just rising through the leafy tops of those trees. As I continued to gaze, all of a sudden a covering seemed to fall away from my eyes, and I found the world bathed in a wonderful radiance, with waves of beauty and joy swelling on every side. This radiance pierced in a moment through the folds of sadness and despondency which had accumulated over my heart, and flooded it with this universal light.

Sun, moon and stars: Tagore's visionary faith was anchored to them.

But the cosmic takes us away from the human, and for Tagore — committed to his fellow human beings in his literary, educational and rural development work — *pūrṇatā* demanded that humanity be placed at the centre. He felt, in fact, more in sympathy with India's *dvaita* or dualism than with *advaita* or monism (which could slide into world-denying asceticism): with forms of religion that expressed a human, loving relationship between Man and the Divine — provided they did not lapse, like some kinds of Vaishnavism, into irrational devotionalism. *The Religion of Man* was a manifesto of his religious humanism. God represents the best in us, our capacity for love, goodness and self-sacrifice. He is rooted in our personal experience of love and suffering. To the traditional Indian belief that *Brahman* (the universal spirit) and *Ātman* (the human soul) are essentially one, Tagore added a crucial emphasis on human sensitivity and feeling. His own feelings had been deepened by acute experience of bereavement: the death by suicide of his beloved sister-in-law Kadambari in 1884; the deaths by illness of his wife in 1902 and three of his five children in 1903, 1907 and 1918. The cultivation of sensitivity was one of the chief aims of education, as he saw it. It was also perhaps a guiding purpose behind many of his poems, stories, plays and songs: to civilize people by making them feel more deeply.

The third aspect of Tagore's spirituality relates to his creative inspiration: his sense — whether exhilarated, humble, awestruck or baffled — that his creative fecundity came from some force outside; that his creativity as an artist was related to the evolving creativity of the Universe itself. He called this force his *jīban-debatā*, his 'life-god'. Sometimes it manifested itself in the beauties (and terrors) of Nature; sometimes in his dreams or subconscious; sometimes it took the form of a *mānas-sundarī*, a Muse or 'Lady of the Mind', who also seemed to emanate from women he had known and loved and who now haunted him. More intimate than his pantheism, less moral than his Religion of Man, this third aspect of the spirit was the driving-force behind the mysterious subtlety of his songs, or the

weird imagery of his paintings. It made him an artist, not a yogi or Holy Man.

Tagore's creative blending of idealism with realism, the cosmic with the human, the romantic with the rational made him a ceaseless experimenter. He subscribed to no dogmatic formula; World and Spirit were in a constantly changing, dynamic relationship, and as an artist Tagore had to find ways of expressing that relationship. Verse forms moved forward, from rule-governed metres to relaxed folk-measures or the *gadya-kabitā* ('prose-poetry') of his late phase. New kinds of fiction were developed, from the limpid short stories he wrote in the 1890s to the wide social canvas of *Gora* (1910) or *The Home and the World* (1916), or the *avant-garde* daring of *Caturaṅga* ('Quartet', 1916) or *Cār Adhyāy* ('Four Chapters', 1934). His plays moved from the Shakespeareanism of *Bisarjan* ('Sacrifice', 1890) to the symbolism of the plays and dance-dramas he wrote for performance by staff and students at Santiniketan. In his late sixties he embarked on yet another experiment, painting — exhibiting internationally and laying out new and startling paths for the development of modern Indian art. His school and university at Santiniketan — and his rural reconstruction project at neighbouring Sriniketan — were his bravest experiment of all. Visva-Bharati, whose name means both 'universal [goddess of] learning' and 'all-India' and whose Sanskrit motto means 'where the whole world meets in one nest', was planned as the institutional embodiment of *pūrṇatā;*

and in the coming millennium, after years when it has inevitably proved difficult to sustain Visva-Bharati's vision and energy in the absence of its founder, it may yet become so.

Because Tagore was so open to imaginative experiment, so encouraging of it in his pupils at Santiniketan, he would surely have welcomed an experiment such as the present book. It belongs to a new wave in the Western appreciation and adaptation of Tagore: a wave that has produced, in the English-speaking world, new translations and editions of his works, new musical settings of his poems (notably by Param Vir and Knut Nystedt), a path-breaking production of *The Post Office*, and an opera, *Snatched by the Gods* by Param Vir, based on Tagore's riveting narrative poem *Debatār Grās* (1900).[1] In Germany, the wave had been led by the writer and Tagore scholar Martin Kämpchen, who has lived at Santiniketan for many years. His own translation of *The Post Office* was produced in Switzerland in 1989 by Wolfram Mehring (a Bengali version of the production was staged in Calcutta in 1991); and his books on Tagore include two that combine — like this book — poems with photographs: *Auf des Funkens Spitzen* (Kösel-Verlag, München, 1989) and *Am Ufer der Stille* (Benziger Verlag, Solothurn and Düsseldorf, 1995).

It was Tagore's very short poems — the epigrams and aphorisms that were collected in *Kaṇikā* ('Particles', 1899), *Lekhan* ('Jottings', 1927) and the posthumous *Sphuliṅga* ('Sparks', 1945) — that

Martin Kämpchen felt worked particularly well with photographs. John Berridge agrees, and has included aphorisms from Tagore's English language collections *Stray Birds* (1917) and *Fireflies* (1928),[2] as well as the translations he has commissioned from me of eleven aphorisms from *Sphuliṅga* .

Using his artistic intuitions as a gifted and fastidious photographer, frequent visitor to India, and long-standing admirer of Tagore, Dr. Berridge has, however, striven for *pūrṇatā* by selecting a variety of texts in addition to the aphorisms. His three chosen translators represent the balance that is essential if international understanding of Tagore is to grow: between Tagore's own self-projection through English, the efforts of a non-Bengali translator such as myself, and a Bengali translator into English such as Ketaki Kushari Dyson. Together with Dr. Berridge, we stand for the principle of international friendship and co-operation that Tagore held so dear and tried to foster at Visva-Bharati.

In Tagore's book of poems *Balākā* ('Wild Birds', 1916), whose title poem has been included in the present selection, there are two other very famous poems in which (as in the title poem) movement and stillness are central themes. In 'Shah-Jahan' (which can be read in English in my Penguin book, *Selected Poems* of Tagore) the poet meditates on the sublime beauty of the Taj Mahal, the tomb that the Emperor Shah-Jahan built — over twenty-two years, 1630–52 — for his favourite queen Mumtaz-i-Mahal. The Taj is a poem in stone, the Emperor's 'heart's picture':

> *The names you softly*
> *Whispered to your love*
> *On moonlit nights in secret chambers live on*
> *Here*
> *As whispers in the ear of eternity.*
> *The poignant gentleness of love*
> *Flowered into the beauty of serene stone.*

[1] *The Post Office* was produced in 1993 by the Oxford-based director Jill Parvin. Building on the harrowing yet uplifting fact that the play was performed in 1942 by Jewish orphans in the care of the pediatrician and educationist Janusz Korczak (1878–1942), it was realized as a play-within-a-play. The Tagore Centre UK's edition (1996) records this production. *Snatched by the Gods* was commissioned by Hans Werner Henze for the 1992 Münchener Biennale and performed with its companion piece *Broken Strings* by the Netherlands Opera. In 1996 it was performed in a new production at the Almeida Theatre, London.

[2] These two books contained translations from *Kaṇikā* and *Lekhan* (itself a bilingual work), and a considerable number of aphorisms written in English. Of the 35 chosen for the present volume, only 8 have identifiable Bengali sources. See *The English Writings of Rabindranath Tagore*, Volume One, Poems, ed. Sisir Kumar Das (Sahitya Akademi, New Delhi, 1994).

Yet the serene stillness of its beauty evokes a spirit of life and love that cannot be confined with a stone memorial:

Tombs remain forever with the dust of this earth:
 It is death
That they carefully preserve in a casing of memory.
 But who can hold life?
The stars claim it: they call it to the sky,
 Invite it to new worlds, to the light
 Of new dawns....

In 'Picture',[3] which Ketaki Kushari Dyson translated for her book *I Won't Let You Go*, the poet perceives in a picture of his dead sister-in-law Kadambari Devi a spirit of love that is as real and living as Nature and the cosmos because it has become part of his being:

Before my eyes you are not;
right within my eyes are you installed.
 That is why
you are the green of my greens, the blue of my blues.
 My whole world
 has found its inner harmony in you.
 No one knows, not even I,
 that your melodies reverberate in my songs.

You are the poet within the poet's heart.
You are not a picture. No, not just a picture....

In both poems, one way of looking at things is rejected in favour of another. In 'Shah-Jahan', the Emperor's dream that his love could be frozen in Time by a building is rejected as 'Lies', because love is life and has to keep moving forward. In 'Picture', the idea that a picture is 'only a picture' and therefore unreal is rejected as 'delirium': the picture reveals a reality much greater than itself. Yet both perspectives are necessary: the stillness of the Taj Mahal or the picture *and* the life-flow of the love that they evoke.

By combining photographs with words, John Berridge's book aims too at this double perspective. Photographs can of course express movement, but most of his photographs are truly 'still': I know from what he has told me and from what I have seen that the criterion by which he selects from the hundreds of exposures he takes is a quality of stillness or quietness. Yet, as Tagore himself put it:

The centre is still and silent in the heart of
an eternal dance of circles.

(p.69)

[3] The poems in *Balākā* are untitled. Later, the poems that were chosen for inclusion in *Sañcayitā*, Tagore's own one-volume selection of his poems, were given titles.

Pūrṇatā requires the dance of circles to be there as well: it will be found, we hope, in the words of Tagore's poems and aphorisms, even if the rhythm and choreography of the dance differ from what they are in Bengali.

Taken together, the photographs should lead to the words and the words should lead back to the photographs:

> *Words move, music moves*
> *Only in time; but that which is only living*
> *Can only die. Words, after speech, reach*
> *Into the silence. Only by the form, the pattern,*
> *Can words or music reach*
> *The stillness, as a Chinese jar still*
> *Moves perpetually in its stillness...*

The connections — not too literal, not too explicit — that readers of the book are invited to discover are perhaps akin to those that exist between Eliot and Tagore, great contemporaries, the Westerner and the Indian, never directly in contact, but connected nonetheless in time and preoccupation.[4] I feel honoured to be a part of the book, and of the patient, painstaking work of international appreciation of Tagore that it furthers.

William Radice
Riding Mill, Northumberland, England,
April 1997

[4] The superb translation that Tagore did in 1933 of 'Journey of the Magi' suggests a deeper affinity between Tagore and Eliot than between Tagore and the Western poet with whom he was historically associated: W. B. Yeats. The lines I have quoted are from 'Burnt Norton' (1935) in *Four Quartets* .

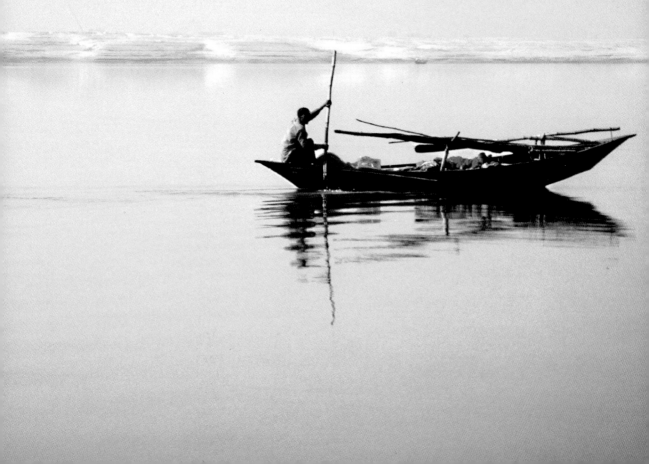

THE GOLDEN BOAT

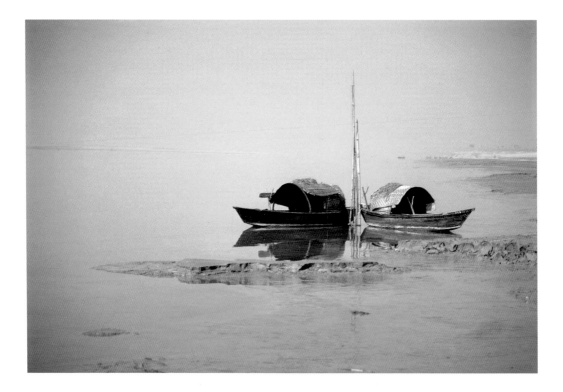

Unending Love

I seem to have loved you in numberless forms, numberless times,
In life after life, in age after age forever.
My spell-bound heart has made and re-made the necklace of songs
That you take as a gift, wear round your neck in your many forms
In life after life, in age after age forever.

Whenever I hear old chronicles of love, its age-old pain,
Its ancient tale of being apart or together,
As I stare on and on into the past, in the end you emerge
Clad in the light of a pole-star piercing the darkness of time:
You become an image of what is remembered forever.

You and I have floated here on the stream that brings from the fount
At the heart of time love of one for another.
We have played alongside millions of lovers, shared in the same
Shy sweetness of meeting, the same distressful tears of farewell —
Old love, but in shapes that renew and renew forever.

 Today it is heaped at your feet, it has found its end in you,
The love of all man's days both past and forever:
Universal joy, universal sorrow, universal life,
The memories of all loves merging with this one love of ours —
And the songs of every poet past and forever.

1890

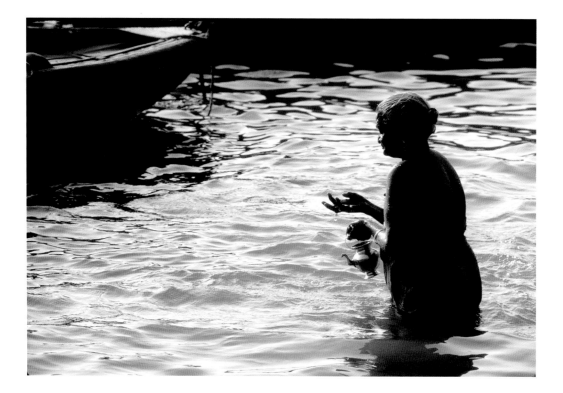

The Golden Boat

Clouds rumbling in the sky; teeming rain.
I sit on the river-bank, sad and alone.
The sheaves lie gathered, harvest has ended,
The river is swollen and fierce in its flow.
As we cut the paddy it started to rain.

One small paddy-field, no one but me —
Flood-waters twisting and swirling everywhere.
Trees on the far bank smear shadows like ink
On a village painted on deep morning grey.
On this side a paddy-field, no one but me.

Who is this, steering close to the shore,
Singing? I feel that she is someone I know.
The sails are filled wide, she gazes ahead,
Waves break helplessly against the boat each side.
I watch and feel I have seen her face before.

Oh to what foreign land do you sail?
Come to the bank and moor your boat for a while.
Go where you want to, give where you care to,
But come to the bank a moment, show your smile —
Take away my golden paddy when you sail.

Take it, take as much as you can load.
Is there more? No, none, I have put it aboard.
My intense labour here by the river —
I have parted with it all, layer upon layer:
Now take me as well, be kind, take me aboard.

No room, no room, the boat is too small.
Loaded with my gold paddy, the boat is full.
Across the rain-sky clouds heave to and fro,
On the bare river-bank, I remain alone —
What I had has gone: the golden boat took all.

1894

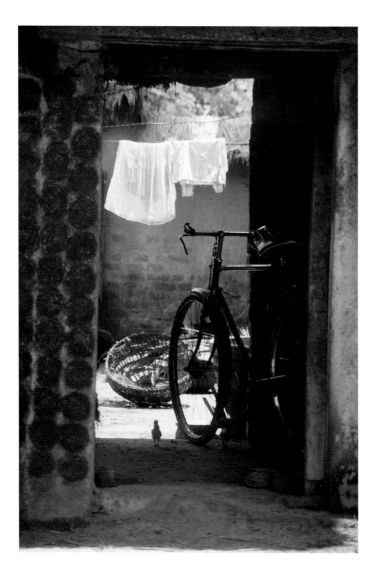

An Ordinary Person

A stick under his arm, a pack on his head,
at dusk a villager goes home along the river.
If after a hundred centuries somehow –
by some magic – from the past's kingdom of death
this peasant could be resurrected, again made flesh,
with this stick under his arm and surprise in his eyes,
then would crowds besiege him on all sides,
everyone snatching every word from his lips.
His joys and sorrows, attachments and loves,
his neighbours, his own household,
his fields, cattle, methods of farming: all
they would take in greedily and still it wouldn't be enough.
His life-story, today so ordinary,
will, in those days, seem charged with poetry.

1896

The Ferry

A ferry-boat crosses and re-crosses the river.
Some go home, some go away from home.
Two villages on two banks know each other.
From dawn to dusk the folks go to and fro.
Elsewhere so many strifes, disasters happen;
histories are made, unmade, re-written.
Foaming upon cascades of spilt blood,
crowns of gold like bubbles swell and burst.
Civilisation's latest hungers, thirsts
throw up so many toxins, honeyed draughts.
Here on two banks two villages stare at each other,
to the big wide world their names quite unknown.
Daily the ferry-boat plies upon the waters,
with some going home, some going away from home.

1896

Drought

In olden days, I've heard, gods in love
with mortal women used to descend from heaven.
Those days are gone. It's Baishakh, the dry season,
a day of burnt out fields and shrunken streams.
A peasant's daughter, piteously suppliant,
begs again and again, 'Come, rain, come!'
Her eyes grieving, restless, and expectant,
from time to time she casts a look at the sky.
But no rain falls. The wind, deaf to her cries,
rushes past, dispersing all the clouds,
and the sun has licked all moisture from the sky
with its tongue of fire. Alas, these degenerate days
the gods are senile. And women can only appeal
to mortal men.

1896

Big Sister

They dig by the river for bricklaying —
labourers from the west country. Their little girl
keeps scampering to the ghat. Such scrubbing and scouring
of pots and pans and dishes! Comes running
a hundred times a day, brass bangles jangling
clang clang against the brass plates she cleans.
So busy all day! Her little brother,
bald, mud-daubed, not a stitch on his limbs,
follows her like a pet, patiently sits
on the high bank, as Big Sister commands.
Plates against her left side, a full pitcher on her head,
the girl goes back, the child's hand in her right hand.
A surrogate of her mother,
bent under her work-load, such a wee Big Sister!

1896

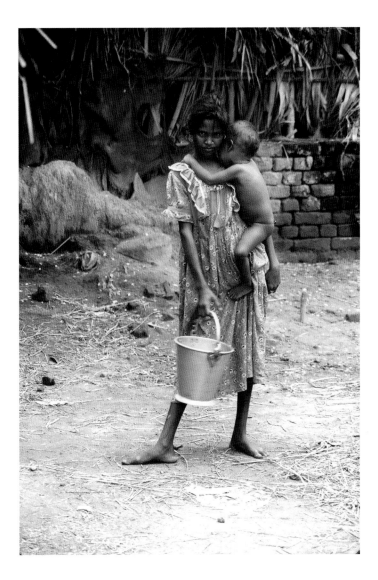

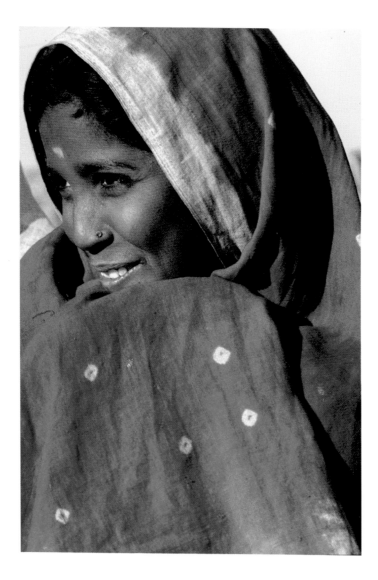

New Rain

It dances today, my heart, like a peacock it dances, it dances.
 It sports a mosaic of passions
 Like a peacock's tail,
It soars to the sky with delight, it quests, O wildly
It dances today, my heart, like a peacock it dances.

Storm-clouds roll through the sky, vaunting their thunder, their thunder.
 Rice-plants bend and sway
 As the water rushes,
Frogs croak, doves huddle and tremble in their nests, O proudly
Storm-clouds roll through the sky, vaunting their thunder.

Rain-clouds wet my eyes with their blue collyrium, collyrium.
 I spread out my joy on the shaded
 New woodland grass,
My soul and *kadamba*-trees blossom together, O coolly
Rain-clouds wet my eyes with their blue collyrium.

Who wanders high on the palace-tower, hair unravelled, unravelled —
 Pulling her cloud-blue sari
 Close to her breast?
Who gambols in the shock and flame of the lightning, O who is it
High on the tower today with hair unravelled?

Who sits in the reeds by the river in pure green garments, green garments?
 Her water-pot drifts from the bank
 As she scans the horizon,
Longing, distractedly chewing fresh jasmine, O who is it
Sitting in the reeds by the river in pure green garments?

Who swings on that *bakul*-tree branch today in the wilderness, wilderness —
 Scattering clusters of blooms,
 Sari-hem flying,
Hair unplaited and blown in her eyes? O to and fro
High and low swinging, who swings on that branch in the wilderness?

Who moors her boat where *ketakī*-trees are flowering, flowering?
 She has gathered moss in the loose
 Fold of her sari,
Her tearful rain-songs capture my heart, O who is it
Moored to the bank where *ketakī*-trees are flowering?

It dances today, my heart, like a peacock it dances, it dances.
 The woods vibrate with cicadas,
 Rain soaks leaves,
The river roars nearer and nearer the village, O wildly
It dances today, my heart, like a peacock it dances.

1900

Offerings (Naibedya) - 88

This I must admit: how one becomes two
is something I haven't understood at all.
How anything ever happens or one becomes what one is,
how anything stays in a certain way, what we mean
by words like *body, soul, mind*: I don't fathom,
but I shall always observe the universe
quietly, without words.

 How can I
even for an instant understand the beginning, the end,
the meaning, the theory — of something outside of which
I can never go? Only this I know —
that this thing is beautiful, great, terrifying.
various, unknowable, my mind's ravisher.

This I know, that knowing nothing, unawares,
the current of the cosmos's awareness flows towards you.

1901

Arrival

Our work was over for the day, and now the light was fading;
We did not think that anyone would come before the morning.
 All the houses round about
 Dark and shuttered for the night —
One or two amongst us said, 'The King of Night is coming.'
We just laughed at them and said, 'No one will come till morning.'

And when on outer doors we seemed to hear a knocking noise,
We told ourselves, 'That's only the wind, they rattle when it blows.'
 Lamps snuffed out throughout the house,
 Time for rest and peacefulness —
One or two amongst us said, 'His heralds are at the doors.'
We just laughed and said, 'The wind rattles them when it blows.'

And when at dead of night we heard a strange approaching clangour,
We thought, sleep-fuddled as we were, it was only distant thunder.
 Earth beneath us live and trembling,
 Stirring as if it too were waking —
One or two were saying, 'Hear how the wheels of his chariot clatter.'
Sleepily we said, 'No, no, that's only distant thunder.'

And when with night still dark there rose a drumming loud and near,
Somebody called to all, 'Wake up, wake up, delay no more!'
 Everyone shaking now with fright,
 Arms wrapped close across each heart —
Somebody cried in our ears, 'O see his royal standard rear!'
At last we started up and said, 'We must delay no more.'

O where are the lights, the garlands, where are the signs of celebration?
Where is the throne? The King has come, we made no preparation!
 Alas what shame, what destiny,
 No court, no robes, no finery —
Somebody cried in our ears, 'O vain, O vain this lamentation:
With empty hands, in barren rooms, offer your celebration.'

Fling wide the doors and let him in to the lowly conch's boom;
In deepest dark the King of Night has come with wind and storm.
 Thunder crashing across the skies,
 Lightning setting the clouds ablaze —
Drag your tattered blankets, let the yard be spread with them:
The King of Grief and Night has come to our land with wind and storm.

1906

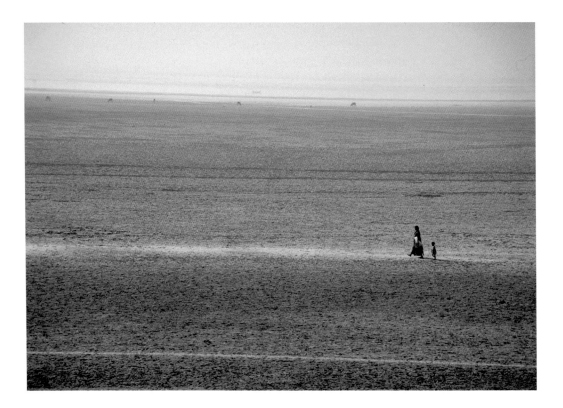

Letter 1889

Our boat has been moored by a sandbank opposite Shelidah. It's a huge, desolate sandbank, stretching out of sight: with slivers of river-water here and there, or expanses of wet sand that look like water. No village, no people, no trees, no grass - but monotony is broken by patches of cracked, wet black earth, alternating with dry white sand. If you turn and look to the east, an endless blueness meets an endless pale yellowness. The sky is empty and the earth too is empty: dry, harsh, barren emptiness below; ample, airy emptiness above. I have never seen such desolation. If you look round to the west again, you see a small kink in the river where the stream scarcely flows, a high bank, and beyond that huts and trees, wonderfully dream-like in the evening sunlight. It's as though on one side you have Creation and the other Destruction. I say 'evening sunlight', because we go out for a walk in the evening and I have a mental picture of the scene as it is then. If you stay in Calcutta you forget how extraordinarily beautiful the world really is. It's only when you are here, and can see the sun setting behind the peaceful riverside trees, and thousands of stars appearing above the unending, pale, lonely, silent sandbank, that you realize how amazing these daily events are. The sun seems to open a huge book each morning, and by the evening a huge page has been turned in the sky above: what extraordinary things are written on it! And this narrow river and vast sandbank, and the picture-like bank opposite with its plain fields beyond, are a vast, silent, secluded school being taught from the book.

Chinnapatrābalī, Letter No. 3,
Shelidah, 28-30 November 1889,
to his niece Indira Devi

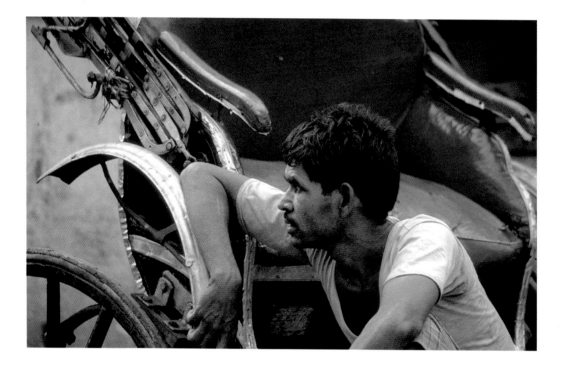

Letter 1894

Over the far side of the river the water-level has been going down, but on this side it's still rising. I'm getting to know it better wherever I go. Huge trees, their trunks under water, stand with branches drooping into the water. Right in the midst of the shady gloom of banyan and banana trees, boats are moored and villagers bathe. Huts are dotted around in the streaming water, their yards completely submerged. No sign of the fields – just the tips of rice-plants poking out of the water. I've lost count of all the lakes, ditches, rivers and canals I've sailed through. After swishing through a paddy-field the boat suddenly entered a village pond, where there was no more paddy, but patches of lotus with white flowers blooming and black cormorants diving for fish. Next, we were in a small river: paddy-fields on one bank, and on the other a village surrounded by dense bushes, with fast streams of water snaking through them. Water enters wherever it's convenient: you've never seen land so utterly vanquished. Villagers move by sitting in large earthenware bowls, using pieces of split bamboo as oars – there are no banks or paths at all. If the water rises any more it will enter their homes – then they'll have to fix up a scaffold and live on their roofs. The cattle will die after standing knee-deep in water all the time, with no grass left for them to eat. Snakes will desert their flooded holes and seek refuge on the roofs of houses, and all the beetles and bugs and reptiles of the area, too, will look for human company. The villages here are shaded all round by jungle – its leaves and creepers and bushes go rotten in the water. Refuse from houses and cowsheds floats about; rotten, stinking jute turns the water blue; naked sickly children with swollen bellies and skinny legs jump and splash and wallow in the water and mud; clouds of mosquitoes buzz over fetid, stagnant water. Altogether the villages here become so unhealthy and uncomfortable during the monsoon that it makes one ill even to pass them. It's awful to see the womenfolk in their sopping saris rolled up to their knees, wading through water like patient beasts in the chilly monsoon air and pouring rain. I can't imagine how people can keep going at all in such difficult and wretched conditions. In every

household people are plagued by rheumatism; their legs swell up; they catch colds and fevers; sick children howl and wail incessantly – nothing can save them, and one by one they die. Such neglect and unhealthiness and squalor and poverty and barbarism in human habitations are terrible to see. The villagers are victims of every kind of oppression: they have to endure the ravages of Nature and of landlords - and no one dares to question the age-old processes that create such unbearable misery.

Chinnapatrābalī, Letter No. 153,
'on the boat to Dighapatiya,' 20 September 1894,
to Indira Devi

Fireflies

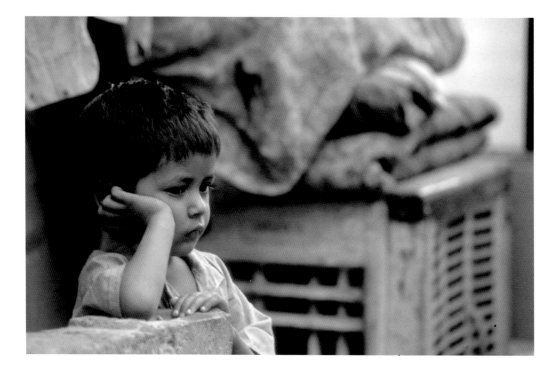

The fireflies, twinkling among leaves,
make the stars wonder.

Fireflies

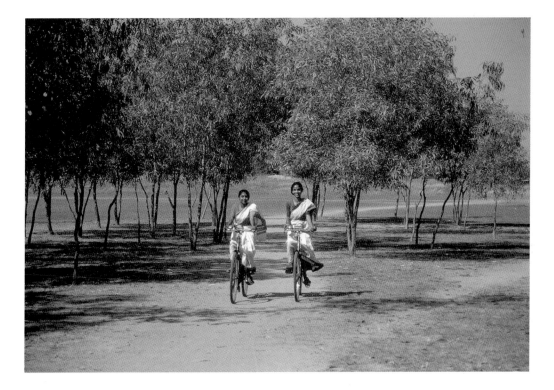

I leave no trace of wings in the air,
but I am glad I have had my flight.

Fireflies

These paper boats of mine are meant to dance
on the ripples of hours,
and not to reach any destination.

Stray Birds 116

The earth hums to me today in the sun, like a
woman at her spinning, some ballad of the ancient
time in a forgotten tongue.

Stray Birds 150

My thoughts shimmer with these shimmering leaves and my heart sings with the touch of this sunlight; my life is glad to be floating with all things into the blue of space, into the dark of time.

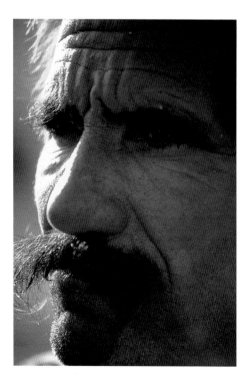

Stray Birds 10

Sorrow is hushed into peace in my heart like
the evening among the silent trees.

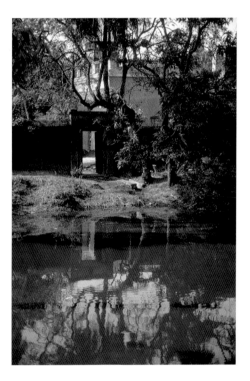

Stray Birds 281

I have seen thee as the half-awakened child sees his mother in the dusk of the dawn and then smiles and sleeps again.

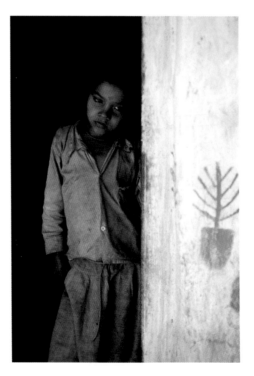

Fireflies

Love is an endless mystery,
 for it has nothing else to explain it.

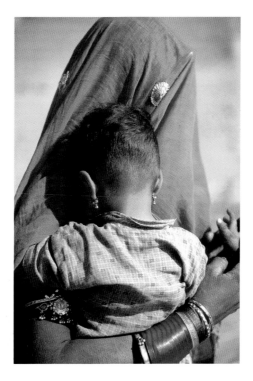

Stray Birds 272

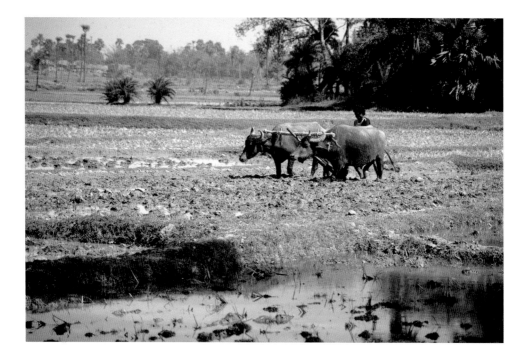

I came to your shore as a stranger, I lived in
your house as a guest, I leave your door as a
friend, my earth.

Stray Birds 290

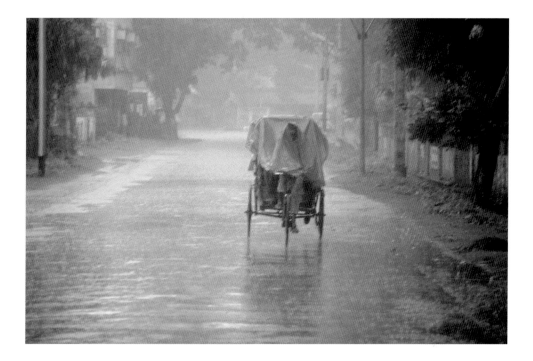

When I stand before thee at the day's end thou
shalt see my scars and know that I had my wounds
and also my healing.

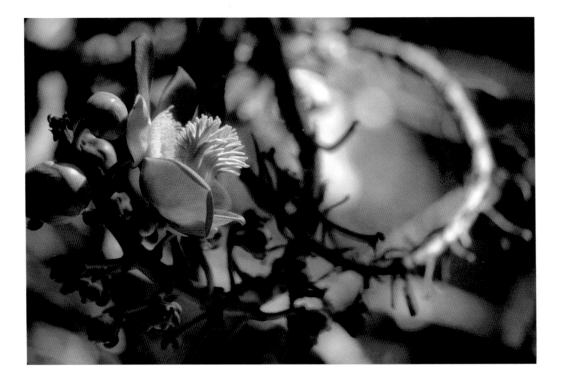

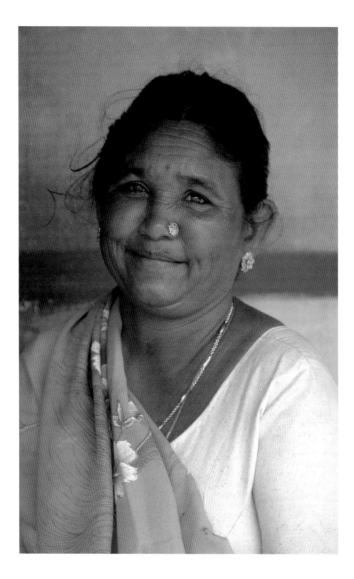

Fireflies

My offerings are not for the temple at the end
of the road,
but for the wayside shrines
that surprise me at every bend.

—

I miss the meaning of my own part
in the play of life
because I know not the parts
that others play.

Fireflies

Dead leaves when they lose themselves in soil
 take part in the life of the forest.

—

Emancipation from the bondage of the soil
 is no freedom for the tree.

—

The butterfly flitting from flower to flower
 ever remains mine,
 I lose the one that is netted by me.

—

The flower sheds all its petals
 and finds the fruit.

Stray Birds 110

Man goes into the noisy crowd to drown his
own clamour of silence.

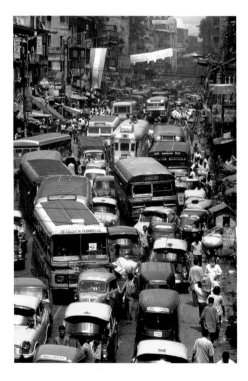

Stray Birds 77

Every child comes with the message that God
is not yet discouraged of man.

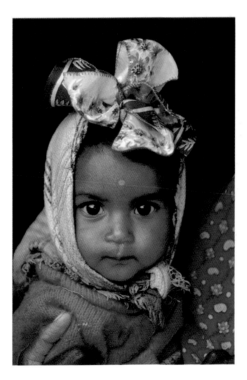

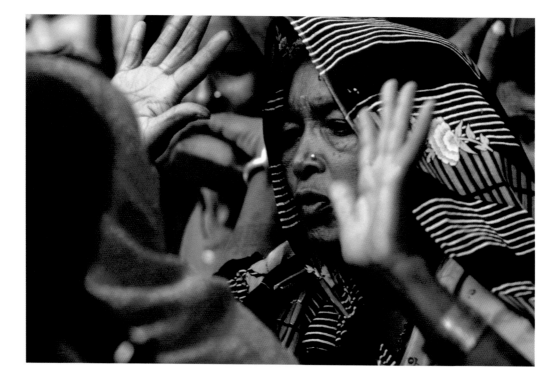

Stray Birds 43

The fish in the water is silent, the animal on the earth is noisy, the bird in the air is singing.

But Man has in him the silence of the sea, the noise of the earth and the music of the air.

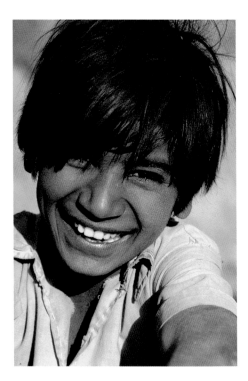

Fireflies

From the solemn gloom of the temple
children run out to sit in the dust,
God watches them play
and forgets the priest.

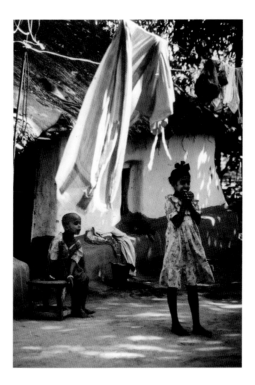

Stray Birds 151

God's great power is in the gentle breeze, not in the storm.

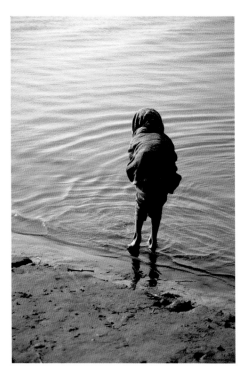

Stray Birds 90

In darkness the One appears as uniform; in
the light the One appears as manifold.

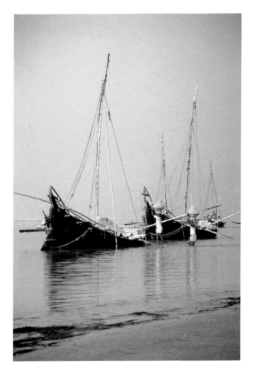

Stray Birds 126

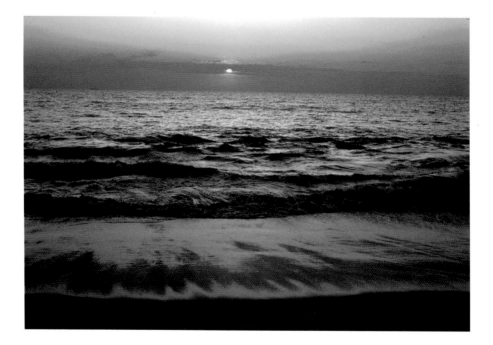

Not hammer-strokes, but dance of the water
sings the pebbles into perfection.

Stray Birds 322

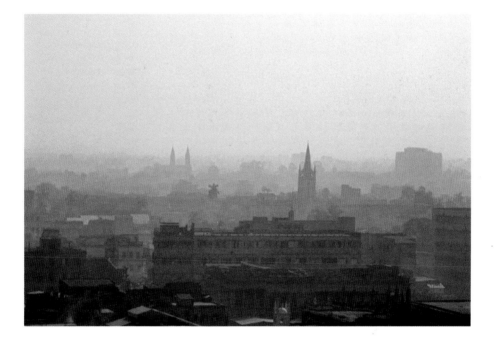

Things look phantastic in this dimness of the
dusk — the spires whose bases are lost in the dark
and tree tops like blots of ink. I shall wait for
the morning and wake up to see thy city in the light.

.

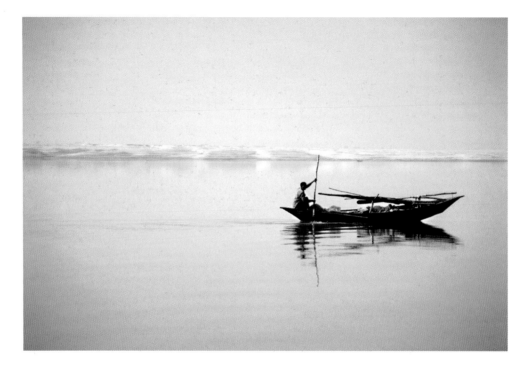

I think of other ages that floated upon the
stream of life and love and death and are forgotten,
and I feel the freedom of passing away.

Fireflies

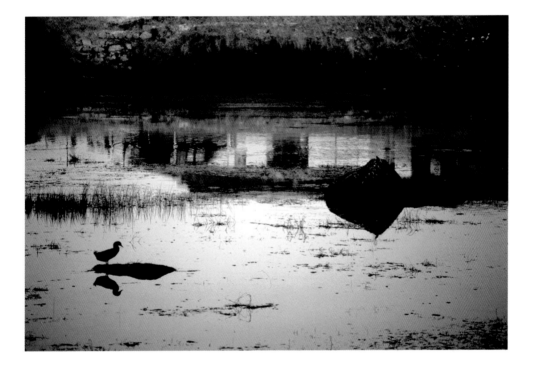

Let the evening forgive the mistakes of the
day
and thus win peace for herself.

Stray Birds 241

Thou hast led me through my crowded travels
of the day to my evening's loneliness.
 I wait for its meaning through the stillness
of the night.

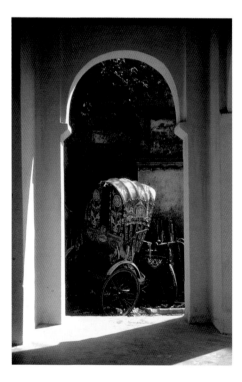

Fireflies

The centre is still and silent in the heart
of an eternal dance of circles.

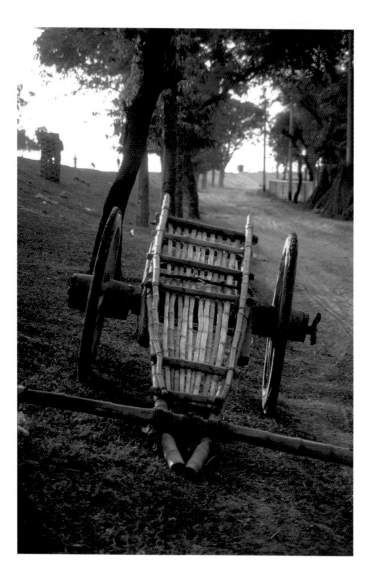

Stray Birds 269

I have learnt the simple meaning of thy whisper
in flowers and sunshine – teach me to know thy
words in pain and death.

Stray Birds 242

This life is the crossing of a sea, where we meet
in the same narrow ship.
 In death we reach the shore and go to our
different worlds.

Fireflies

Before the end of my journey
 may I reach within myself
 the one which is the all,
 leaving the outer shell
 to float away with the drifting multitude
 upon the current of chance and change.

WILD BIRDS

A Flight of Wild Birds (Balākā) - 36

Glimmering in evening's colours, Jhelum's curved stream
 faded in the dark, like a sheathed
 curved sword.
 The day ebbed. Night, in full flood,
rushed in, star-flowers afloat in its black waters.
 In the darkened valley
 deodars stood in rows.
Creation, it seemed, had something to say in its sleep,
 but couldn't speak clearly:
clumps of inarticulate sound moaned in the dark.

 Suddenly that instant I heard
 a sound's lightning-flash in the evening sky:
 it darted across that tract of empty space,
then receded — further, further — till it died.
 Wild birds,
 how your wings drunk on the wine
 of violent gales raised billows of surprise
and merriment's loud laughter in the sky!
 That sumptuous whoosh — it was
 a sonorous nymph of the heavens swishing across,
 disturbing stillness seated in meditation.
 They quivered with excitement —
 the mountains sunk in darkness,
 the deodar-glen.

What those wings had to say
seemed to conduct
just for an instant
velocity's passion
into the very heart of thrilled stillness.
The mountain wished to be Baishakh's vagrant cloud.
The trees — they wanted to untie themselves from the earth,
to spread wings
and follow the line of that sound,
to lose themselves in the quest for the sky's limit.
The dream of that evening burst and ripples rose,
waves of yearning for what was far, far away.
Vagabond wings!
How the universe cried with longing —
'Not here, no, not here, somewhere else!'

Wild birds,
you've lifted the lid of stillness for me tonight.
Under the dome of silence
in land, water, air
I can hear the noise of wings — mad, unquiet.
The grass
beat their wings on their own sky — the earth.
Millions of seed-birds
spread their sprouting wings
from unknown depths of subterranean darkness.
Yes, I can see
these mountains, these forests
travelling with outspread pinions

from island to island, from one unknown to another.
 Darkness is troubled by light's anguished cries
 as the wings of the very stars vibrate.

 Many are the human speeches I've heard migrating
 in flocks, flying on invisible tracks
from obscure pasts to distant inchoate futures.
 And within myself I've heard
 day and night
 in the company of countless birds
a homeless bird speeding through light and dark
 from one unknown shore to yet another.
On cosmic wings a refrain echoes through space:
'Not here, no, but somewhere, somewhere else!'

1915

One Day

I remember that afternoon. From time to time the rain would
slacken, then a gust of wind would madden it again.

It was dark inside the room, and I couldn't concentrate on
work. I took my instrument in my hand and began a monsoon
song in the mode of Mallar.

She came out of the next room and came just up to the door.
Then she went back. Once more she came and stood outside
the door. After that she slowly came in and sat down. She had
some sewing in her hand; with her head lowered, she kept
working at it. Later she stopped sewing and sat looking at the
blurred trees outside the window.

The rain slowed, my song came to an end. She got up and
went to braid her hair.

Nothing but this. Just that one afternoon twined with rain
and song and idling and darkness.

Stories of kings and wars are cheaply scattered in history. But
a tiny fragment of an afternoon story stays hidden in time's box
like a rare jewel. Only two people know of it.

1919

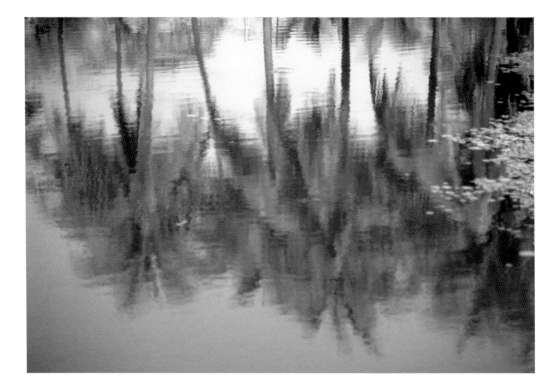

Palm-tree

Palm-tree: single-legged giant,
 topping the other trees,
 peering at the firmament —

It longs to pierce the black cloud-ceiling
 and fly away, away,
 if only it had wings.

The tree seems to express its wish
 in the tossing of its head:
 its fronds heave and swish —

It thinks, Maybe my leaves are feathers,
 and nothing stops me now
 from rising on their flutter.

All day the fronds on the windblown tree
 soar and flap and shudder
 as though it thinks it can fly,

As though it wanders in the skies,
 travelling who knows where,
 wheeling past the stars —

And then as soon as the wind dies down,
 the fronds subside, subside:
 the mind of the tree returns

To earth, recalls that earth is its mother:
 and then it likes once more
 its earthly corner.

1922

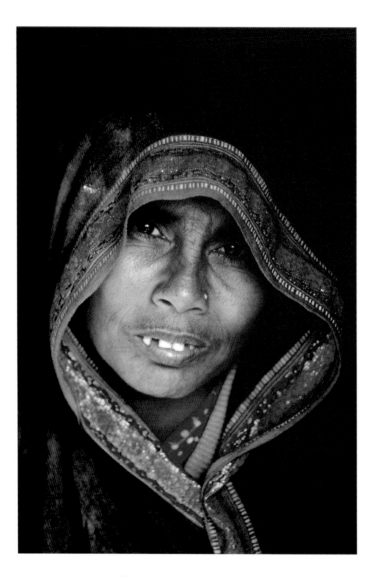

Question

God, again and again through the ages you have sent messengers
 To this pitiless world:
They have said, 'Forgive everyone', they have said, 'Love one another —
 Rid your hearts of evil.'
They are revered and remembered, yet still in these dark days
We turn them away with hollow greetings, from outside the doors of our houses.

And meanwhile I see secretive hatred murdering the helpless
 Under cover of night;
And Justice weeping silently and furtively at power misused,
 No hope of redress.
I see young men working themselves into a frenzy,
In agony dashing their heads against stone to no avail.

My voice is choked today; I have no music in my flute:
 Black moonless night
Has imprisoned my world, plunged it into nightmare. And this is why,
 With tears in my eyes, I ask:
Those who have poisoned your air, those who have extinguished your light,
Can it be that you have forgiven them? Can it be that you love them?

1932

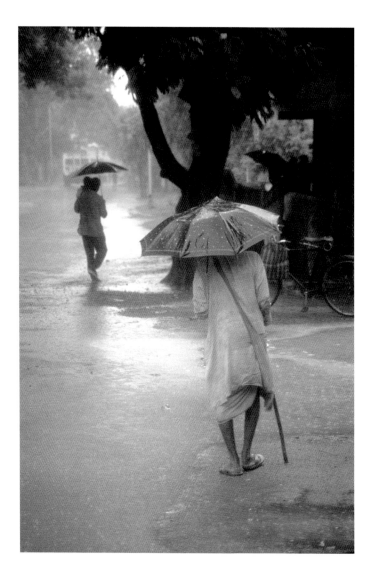

A Person

An oldish man from India's north,
　　skinny and tall.
White moustache, shaved chin,
　　　face like a shrivelled fruit.
Chintz shirt. Dhoti in wrestler-style.
　　Umbrella on left shoulder. Short stick in right hand.
Shoes with turned up toes. He's walking to town.
　　　Bhadra morning.
　　Sun muted by thin clouds.
After a muffled, stifling night
　　a fog-damp breeze
　　vacillates through young amloki twigs.

　　The wayfarer appeared
　　on the outermost line of my universe,
where insubstantial shadow-pictures move.
　　I just knew him to be a person.
　　He had no name, no identity, no pain,
　　　no need whatsoever of anything.
　　　On the road to market
　　on a Bhadra morning
　　　he was just a person.

He saw me too
on the last limits of his world's waste land,
　　　where, within a blue fog,
　　connections between men there were none,
　　　where I was — just a person.

　　At home he has a calf,
　　　a myna in a cage,
a wife, who grinds wheat between stones,
　　　fat brass bangles on her wrists.
He has his neighbours, — a washerman,
　　　a grocer with his shop.
　　He has his debts, — to merchants from Kabul.
　　But nowhere in that world of his
　　　is there me — a person.

1932

The Last Octave (Śeṣ Saptak) - 46

I was then seven years of age.
 Through the dawn window I would spy
 the upper lid of darkness lifting,
 a soft light streaming out
 like a newly opened kantalichampa flower.

Leaving my bed, I would rush into the garden
 before the crow's first cry,
 lest I deprived myself
 of the rising sun's preliminary rites
 among the trembling coconut branches.

Each day then was independent, was new.
 The morning that came from the east's golden ghat,
 bathed in light,
 a dot of red sandal on its forehead,
 came to my life as a new guest,
 smiled to me.
Not a trace of yesterday would there be on its body's wrap.

Then I grew older
 and work weighed me down.
The days jostled against one another,
 losing the dignity that was unique to each.
One day's thinking stretched itself to the next day.
One day's job spread its mat on the next day to sit down.
Time, thus compacted, only expands,
 never renews itself.
Age just increases without pause,
 doesn't return
from time to time to its eternal refrain,
 thus to re-discover itself.

Today it's time for me to make the old new.
 I've sent for the medicine-man: he'll rid me of the ghost.
 For the wizard's letter
 every day I shall sit in this garden.
 A new letter each day
 at my window when I awake.
 Morning will arrive
 to get introduced to me;
 will open its eyes, unblinking, in the sky
 and ask me,
 'Who are you?'
 What's my name today
 won't be valid tomorrow.

The commander sees his army,
 not the soldier;
sees his own needs,
 not the truth;
doesn't see each person's
 unique, creator-shaped form.
Thus have I seen the creation so far —
 like an army of prisoners
bound in one chain of need.
And in that same chain
 I have also bound myself.

 Today I shall free myself.
Beyond the sea
 I can see the new shore before me.
I won't tangle it with
 baggage brought from this shore.
On this boat I'll take no luggage at all.
 Alone I'll go,
made new again, to the new.

1935

Flute-music

Kinu the milkman's alley.
A ground-floor room in a two-storeyed house,
Slap on the road, windows barred.
Decaying walls, crumbling to dust in places
Or stained with damp.
Stuck on the door,
A picture of Gaṇeśa, Bringer of Success,
From the end of a bale of cloth.
Another creature apart from me lives in my room
For the same rent:
A lizard.
There's one difference between him and me:
He doesn't go hungry.

I get twenty-five rupees a month
As junior clerk in a trading office.
I'm fed at the Dattas' house
For coaching their boy.
At dusk I go to Sealdah station
Spend the evening there
To save the cost of light.
Engines chuffing,
Whistles shrieking,
Passengers scurrying,
Coolies shouting.
I stay till half past ten,
Then back to my dark, silent, lonely room.

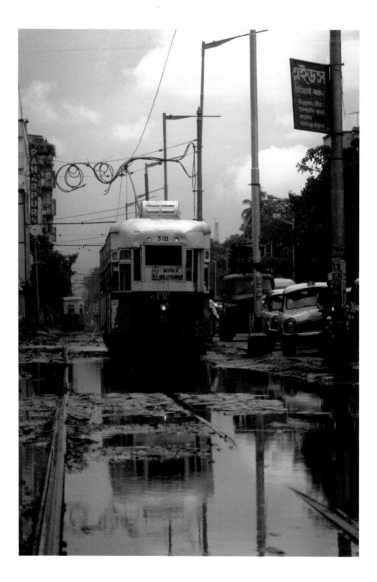

A village on the Dhaleśvarī river, that's where my aunt's people live.
 Her brother-in-law's daughter —
She was due to marry my unfortunate self, everything was fixed.
 The moment was indeed auspicious for her, no doubt of that —
 For I ran away.
 The girl was saved from me,
 And I from her.
She did not come to this room, but she's in and out of my mind all the time:
 Dacca sari, vermilion on her forehead.

 Pouring rain.
 My tram costs go up,
 But often as not my pay gets cut for lateness.
 Along the alley,
 Mango skins and stones, jack-fruit pulp,
 Fish-gills, dead kittens
 And God knows what other rubbish
 Pile up and rot.
 My umbrella is like my depleted pay -
 Full of holes.
 My sopping office clothes ooze
 Like a pious Vaiṣṇava.
 Monsoon darkness
 Sticks in my damp room
 Like an animal caught in a trap,
 Lifeless and numb.
Day and night I feel strapped bodily
 On to a half-dead world.

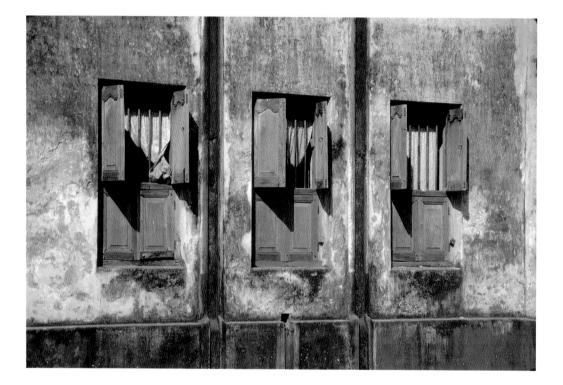

At the corner of the alley lives Kāntabābu —
Long hair carefully parted,
Large eyes,
Cultivated tastes.
He fancies himself on the cornet:
The sound of it comes in gusts
On the foul breeze of the alley —
Sometimes in the middle of the night,
Sometimes in the early morning twilight,
Sometimes in the afternoon
When sun and shadows glitter.
Suddenly this evening
He starts to play runs in Sindhu-Bārōyā rāg,
And the whole sky rings
With eternal pangs of separation.
At once the alley is a lie,
False and vile as the ravings of a drunkard,
And I feel that nothing distinguishes Haripada the clerk
From the Emperor Akbar.
Torn umbrella and royal parasol merge,
Rise on the sad music of a flute
Towards one heaven.

The music is true
Where, in the everlasting twilight-hour of my wedding,
The Dhaleśvarī river flows,
Its banks deeply shaded by *tamāl*-trees,
And she who waits in the courtyard
Is dressed in a Dacca sari, vermilion on her forehead.

1932

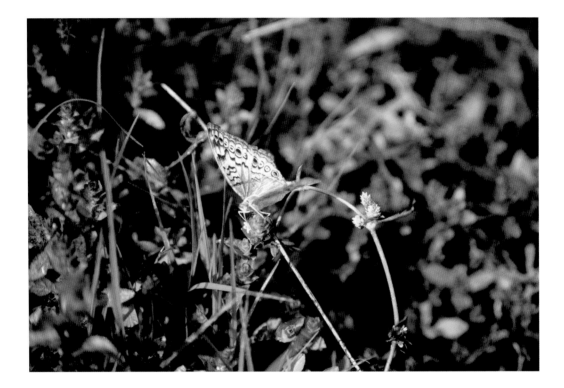

Sphulinga 201

The grandest rainbow's a far-off thing.
I prefer what my patch of earth can bring:
The colours that paint a butterfly's wing.

Sphulinga 164

Too long I've wandered from place to place,
Seen mountains and seas at vast expense.
Why haven't I stepped two yards from my house,
Opened my eyes and gazed very close
At a drop of dew on a stalk of rice?

Sphulinga 49

Lotus in the middle of the lake:
 Who can gather it?
Grass growing under our feet:
 All are served by it.

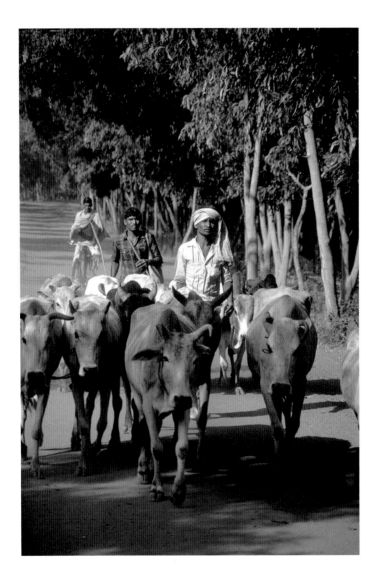

Sphulinga 233

He who knows the truth
Stores it in a treasure chest proudly.
He who loves the truth
Keeps it inside himself humbly.

Sphulinga 126

In empty, indolent leisure
 No peace is found.
Only in truthful work
 Is peace attained.

Sphuliṅga 194

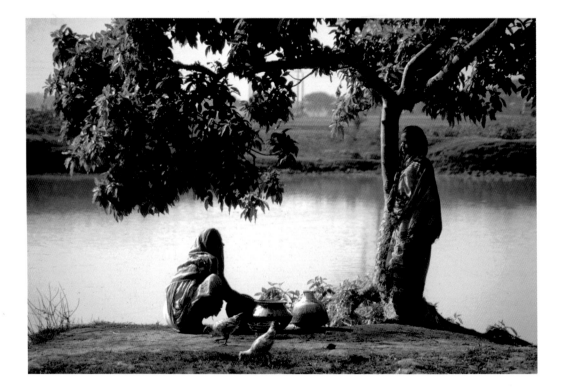

Up to the sky
My free thoughts roam:
In my songs they come home.

Sphuliṅga 249

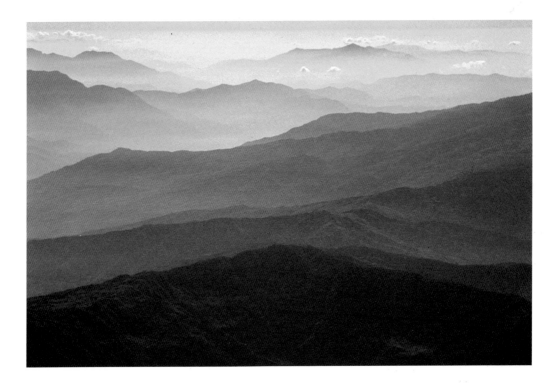

Stillness soars as a mountain-peak,
Seeking its greatness in height.
Movement stops in a silent lake,
Seeking in depth its limit.

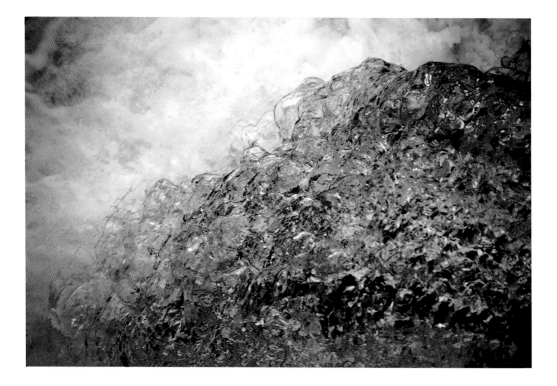

Sphulinga 258

Tree, the message that blooms
 In 1your branches, leaves and flowers
 Enters my heart and inspires
My music's tunes and rhythms.

The evening Lamp

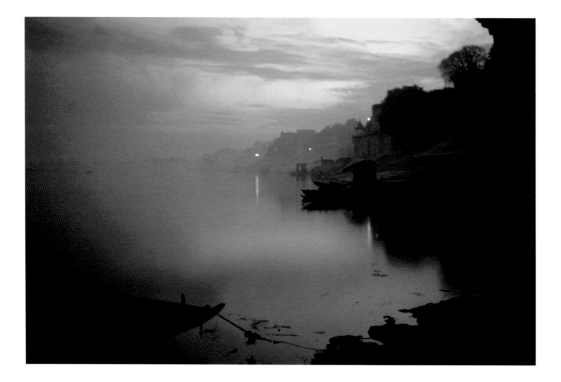

The Borderland (Prāntik) - 9

I saw, in the twilight of flagging consciousness,
My body floating down an ink-black stream
With its mass of feelings, with its varied emotion,
With its many-coloured life-long store of memories,
With its flutesong. And as it drifted on and on
Its outlines dimmed; and among familiar tree-shaded
Villages on the banks, the sounds of evening
Worship grew faint, doors were closed, lamps
Were covered, boats were moored to the ghāts. Crossings
From either side of the stream stopped; night thickened;
From the forest-branches fading birdsong offered
Self-sacrifice to a huge silence.
Dark formlessness settled over all diversity
Of land and water. As shadow, as particles, my body
Fused with endless night. I came to rest
At the altar of the stars. Alone, amazed, I stared
Upwards with hands clasped and said: 'Sun, you have removed
Your rays: show now your loveliest, kindliest form
That I may see the Person who dwells in me as in you.'

1938

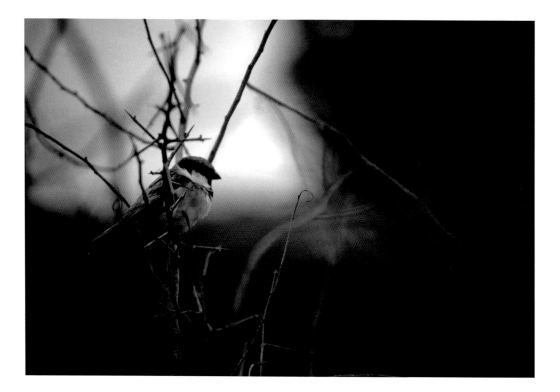

The Borderland (Prāntik) - 10

King of Death, your fatal messenger came to me
Suddenly from your durbar. He took me to your vast courtyard.
My eyes saw darkness; I did not see the invisible light
In the depths and layers of your darkness, the light
That is the source of the universe; my vision
Was clouded by my own darkness. That a great hymn
To light should swell from the inmost cavern of my being
And reach to the realm of light at the edge of creation —
That was why you sent for me. I sang,
Aiming in my melody to bring to the theatre of physical
Existence the poetic glory of the spirit.
But my vīnā could not play the music of destruction,
Could not compose a rāga of silent wrath;
My heart could not engender a serene image of the terrible.
And so you sent me back. The day will come
When my poetry, silently falling like a ripened fruit
From the weight of its fullness of joy,
Shall be offered up to eternity. And then at last
I shall pay you in full, finish my journey, meet your call.

1938

Leaving Home

One in the morning – waking in a flurry,
Fresh sleep ruptured. The clock by his pillow
 Had roused him brusquely with its harsh alarm.
 His time in the house was finished.
 Now, in the cold of Aghrān,
 At the call of merciless duty,
 He must leave family, go to an alien land.
 All that was discardable for now
 Would remain behind:
 The rickety divan with its grimy bedspread;
 The broken-armed easy-chair;
 In the bedroom,
 Balanced on a leaning tepoy
 A spattered old mirror;
 In a corner, a wooden cupboard
 Stuffed with worm-eaten ledger-books;
 Stacked against the walls,
 Piles of outdated almanacs.
 In a niche, a try of withered, abandoned pūjā flowers:
 All of this there in the feeble lamplight,
 Wrapped in shadow, motionless, meaningless.

The taxi brashly honked its presence at the door.
 The deeply sleeping town
 Stayed aloof.
 The distant police-station-bell rang three-and-a-half.

Gazing up at the sky,
Sighing deeply,
He invoked divine protection for his long journey.
Then he padlocked the door of his house.
Dragging his unwilling body,
He moved forward, paused —
Above him, bats' wings
Swept across the black emptiness of the sky
Like shadowy spectres of the cruel fate
That was leading his life into uncertainty.
By the temple, the aged banyan-tree
Had been swallowed by the night as by a snake.
By the bank round the newly-dug tank
Where labourers' dwellings had sprung up
Roofed with date-palm leaves, faint lights flickered.
Near them, the scattered bricks of a tumbledown kiln.
Images of life, outlines blurred
By the ink-wash of night —
Farmers busy all day in the fields cutting paddy;
Girls gossiping, arms round each other's necks;
Boys, released from school,
Scampering raucously;
A sack-laden ox cajoled and shoved to morning market;
Herd-boys floating across to fields on the other side of the river
By clinging to the necks of buffalo —
The ever-familiar play of life as the taxi rushed the traveller
Through the dark, but before its dawn arousal.

As he sped past a weed-filled pond
 The scent of its water
Evoked the cool, tender embrace of many days and nights.
 But on went the car by the winding route
 To the station:
 Rows of houses on either side —
 People inside them comfortably sleeping.
Through gaps between the trees in the dark mango-groves
 The morning-star could be glimpsed,
 Honouring the brow of silence
 With the mark of infinity.
 On the traveller went,
 Alone among sleeping thousands,
While the car that hastened him echoed far and wide
 Down the empty streets,
 Callous in its sound.

1938

Last Tryst

Ink-black clouds banked in the north-east:
The force of the coming storm latent in the forest,
 Waiting as quietly as the bats hanging
In the branches. Darkness blanketing
 Dense leaves that are still and silent
 As a crouching tiger intent
 On its prey. Flocks of crows
Suddenly aloft in a craze
 Of fear, like tattered
 Shreds of darkness littered
Over the void of a cosmos
 Broken into chaos.

Where have you come from today in the guise
 Of a storm, your unbound hair scented with past wild flowers?
 In my youth you came once before on another
 Day, first messenger
 Of the freshly shining Spring.
 You brought the first flowering
Jasmine of Āṣāṛh, you were indescribably lovely.
 You blossomed in my heart,
 In my boundless wonder: I do not know from what
 Radiant world unseen
 You came into the light of vision.
 You meet me today by a path no less mysterious.
 How potent your face

Appears in the brief lightning-flame!
How novel its expressions seem!

Is the path by which you come today
 The same as I knew before?
 I see
 Sometimes its faint outline;
Sometimes not the slightest hint or glimmer can be seen.
You have brought in your basket flowers recalled or forgotten,
 But others I have never hitherto known;
 And in your fragrance you carry
 The message of a season new to me.
 A deathly-dark suffusion
 Obscures its coming revelation.
 O honour me
 With its garland, place it around my neck in this dimly
 Starlit palace of silence. Let this our last
 Tryst
 Carry me into the infinite night
 Beyond all earthly limit;
 Let it make me one
 With the not known.

1940

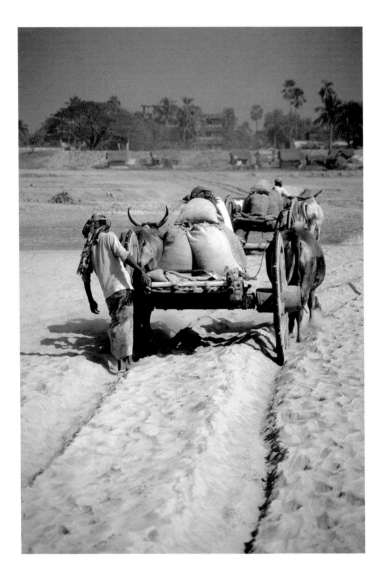

Recovery (Ārogya) - 10

Lazily afloat on time's stream,
My mind turns to the sky.
As I cross its empty expanses
Shadowy pictures form in my eyes
Of the many ages of the long past
And the many peoples
That have hurtled forward,
Confident of victory.
The Pāṭhāns came, greedy for empire;
And the Moghuls,
Brandishing victory-banners,
The wheels of their conquering chariots
Raising webs of dust.
I look at the sky —
No sign of them now today:
Through the ages
The light of sunrise and sunset
Continues to redden the sky's pure blue
At dawn and dusk.
Then others came,
Along tracks of iron
In fire-breathing vehicles —
The mighty British,
Scattering their power
Beneath the same sky.
I know that time will flow along their road too,

Float off somewhere the land-encircling web of their empire.
I know their merchandise-bearing soldiers
Will not make the slightest impression
On planetary paths.

But the earth when I look at it
Makes me aware
Of the hubbub of a huge concourse
Of ordinary people
Led along many paths and in various groups
By man's common urges,
From age to age, through life and death.
They go on pulling at oars,
Guiding the rudder,
Sowing seeds in the fields.
Cutting ripe paddy.
They work —
In cities and in fields.
Imperial canopies collapse,
Battle-drums stop,
Victory-pillars, like idiots, forget what their own words mean;
Battle-crazed eyes and blood-smeared weapons
Live on only in children's stories,
Their menace veiled.
But people work —

Here and in other regions,
Bengal, Bihar, Orissa,
By rivers and shores,
Punjab, Bombay, Gujurat —
Filling the passage of their lives with a rumbling and thundering
Woven by day and by night —
The sonorous rhythm
Of Life's liturgy in all its pain and elation,
Gloom and light.
Over the ruins of hundreds of empires,
The people work.

1941

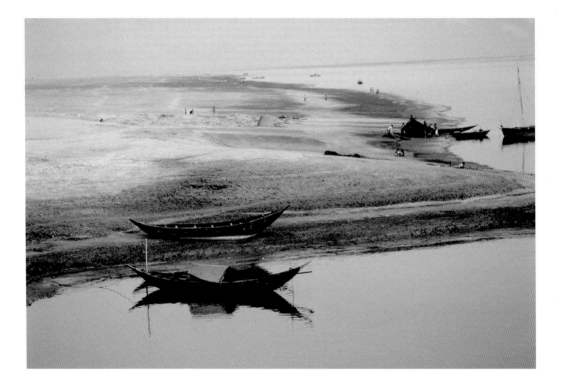

Recovery (Ārogya) ~ 9

In creation's vast field
the play of fireworks in the skies
with suns and stars
is on a cosmic scale.
I too came from the invisible without beginning
with a minute fire-particle to a tiny spot
of space and time.
Now as I enter the last act, the lamp's flame
flickers, the shadows reveal
the illusory nature of this play.
Joys and sorrows, dramatic disguises,
slowly become slack.
Hundreds of actors and actresses through the ages
have left their many-coloured costumes outside the door
of the theatre. I look and see
in the greenroom of hundreds of extinguished stars
the king of the theatre standing still, alone.

1941

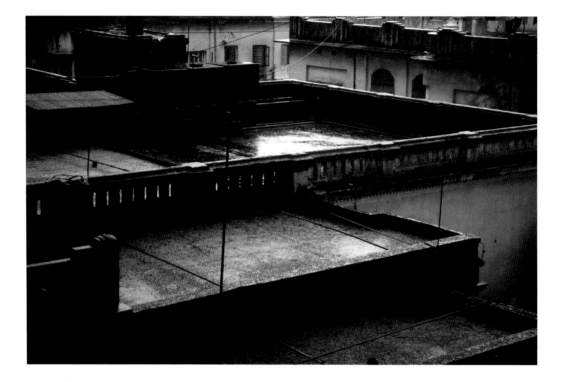

Last Writings (Śeṣ Lekhā) – 13

When existence first manifested itself,
the first day's sun asked:
'Who are you?'
There was no answer.
Years passed.
The day's last sun
put its last question
on the shore of the western ocean
in a hushed evening -
'Who are you?'
but got no answer.

1941

The Photographs

In the state of West Bengal, the photographs were taken in the Bolpur-Santiniketan area, located roughly one hundred miles to the north of Calcutta [pp. 22, 27, 43, 45, 50, 51, 56, 63, 84, 98, 100, 104, 114], and in the city of Calcutta itself [pp. 38, 58, 67, 90, 122]. With the exception of the image on p.70, which was photographed in Dacca, the pictures of Bangladesh were obtained in and near the city of Rajshahi, located on the Padma River [pp. 18, 36, 44, 47, 64, 65, 68, 72, 80, 92, 116, 120]. Other photographs of North India were taken in Delhi [p.42], the city Varanasi, situated on the sacred Ganges River (in the state of Uttar Pradesh) [pp. 4, 7, 20, 59, 106], the village of Khajuraho (in the state of Madhya Pradesh) [pp. 48, 60, 69, 71, 74, 82, 94, 96, 102, 108], and in northern parts of the state of Rajasthan [pp. 30, 46, 49, 62]. The picture of the foothills of the Himalayas [p.101] was made on an excursion flight between Kathmandu (Nepal) and Mount Everest. Photographs of South India were taken in the states of Tamilnadu [p.54], and Kerala [p.52, 66].

The photograph of Rabindranath Tagore with a young boy [p.8], was taken by Sambhu Shaha in Santiniketan in 1938/39, and has been reproduced here by permission of the Rabindra Bhavana, Visva-Bharati, Santiniketan.

The Readings

The following poems have been reprinted from Rabindranath Tagore. Selected Poems, translation copyright © William Radice 1985, 1987, 1993, 1994 (Penguin, London 1994): *Unending Love, The Golden Boat, New Rain, Arrival, Palm-tree, Question, Flute-music, The Borderland (Prāntik) – 9, The Borderland (Prāntik) – 10, Leaving Home, Last Tryst,* and *Recovery (Ārogya) – 10.* The poems have been reproduced here by permission granted by Penguin Books. Poems which have been reprinted by permission of Bloodaxe Books Ltd. from Rabindranath Tagore. I Wont Let You Go. Selected Poems, translation copyright Ketaki Kushari Dyson 1991 (Bloodaxe Books, Newcastle upon Tyne 1991) include: *An Ordinary Person, The Ferry, Against Meditative Knowledge, Drought, Big Sister, The Mediatrix, Offerings (Naibedya) – 88, A Flight of Wild Birds (Balākā) – 36, One Day, A Person, The Last Octave (Śeṣ Saptak) – 46, Recovery (Ārogya) – 9,* and *Last Writings (Śeṣ Lekhā)– 13.* Dr. Dyson's book is presently being reprinted by Bloodaxe Books. The North American distributor is Dufour Editions Inc.The excerpts from Tagore's letters have been reprinted from Rabindranath Tagore Selected Short Stories, translation copyright William Radice © 1994 (Penguin, London, © 1994) by permission of John Johnson Ltd., London. The sayings from *Fireflies* have been reprinted with the permission of Simon & Schuster (New York) and Macmillan General Books (London). Copyright 1928 by Macmillian Publishing Company; copyright © renewed 1956 by Rathindranath Tagore. The sayings from *Stray Birds* (copyright 1917 by Macmillan Publishing Company) have been reprinted with the permission of Macmillan General Books. Best efforts were made to obtain permission from the estate of Dr. Rabindranath Tagore (Visva-Bharati, Santiniketan) to reprint these readings from *Fireflies* and *Stray Birds.* The new translations of the aphorisms from Sphuliṅga have been completed by William Radice.